Bible scripture: Scriptures marked KJV are taken from the KING JAMES VERSION (KJV): KING JAMES VERSION, public domain.

Balboa Press books may be ordered through booksellers or by contacting:

Balboa Press
A Division of Hay House
1663 Liberty Drive
Bloomington, IN 47403
www.balboapress.com
1 (877) 407-4847

Because of the dynamic nature of the Internet, any web addresses or links contained in this book may have changed since publication and may no longer be valid. The views expressed in this work are solely those of the author and do not necessarily reflect the views of the publisher, and the publisher hereby disclaims any responsibility for them.

This book is a work of non-fiction. Unless otherwise noted, the author and the publisher make no explicit guarantees as to the accuracy of the information contained in this book and in some cases, names of people and places have been altered to protect their privacy.

Images on pages #25, 40 and 58 are by permission of North Light Books from Artist's Photo Reference, by Gary Greene

ISBN: 978-1-5043-9374-4 (sc)
978-1-5043-9375-1 (e)

Library of Congress Control Number: 2017918945

Print information available on the last page.

Balboa Press rev. date: 01/10/2018

BALBOA
PRESS
A DIVISION OF HAY HOUSE

A LITTLE BOOK
OF
LOVING AWARENESS

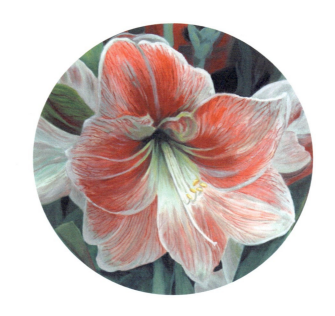

ANNE LINDEN

To my husband, Chris and our children

Tom, Amy, Matthew and Peter

with much love.

PREFACE

Recently I was in California at a spiritual retreat. During a meditation, an idea occurred to me, - a little book of loving awareness. When I returned home to Toronto I was still puzzling what that idea could mean. I am a painter, not a writer. I have always loved poetry, aphorisms, wise sayings: - so why not pull together some of my large floral paintings and add some of the beautiful profound words of writers who have had a lasting effect on my life and my art? This has become my Little Book of Loving Awareness. May it bring you peace and joy.

On early inspiration

When I was seven years old I attended a summer camp on Lake Boshkung, in Ontario. First thing every morning the counsellors would line all us little folk up in a row, on top of a small hill overlooking the lake. On clear days the sun would shine on the dark lake and the bright light would sparkle and play on the surface. We were taught to recite "Look to this day", an ancient exhortation, that I have quoted in the text of the book. I have lived with these words of wisdom for the rest of my life. They are deeply meaningful to me. There is much satisfaction in taking these words to heart.

Flowers as an inspiration

There are many subjects inspiring to a painter. Included could be landscapes, water, people and pets, wild animals, mountains, cityscapes to name just a few, and flowers. Ah yes, flowers.

Flowers just are. They have shape and color and fragrance to attract birds and insects necessary to pollinate and survive as a species. But they are so much more. They are a metaphor for the cycle of life, - budding, blooming, wilting, dying. The swift passage of life to death.

We give and receive flowers as expressions of respect and affection. As spices they flavor our food and drink. We harvest their scent to distil and make expensive perfume. They are always received with graciousness and a smile. The giving of flowers is a universal expression of wellbeing and love. It can be a formal bouquet of red roses thrown at the feet of a diva on the stage of the Metropolitan Opera, or a single golden dandelion given to a mother by her four- year-old.

They represent some of the most noble qualities of life: - beauty, love, patience, purity, integrity, courage, tenacity. I remember stopping dead in my tracks as I almost stepped on a little daisy, pushing its head up through the crack between two pieces of pavement, with its cheeky face turned up as if to say, "never give up, never give up!"

Flowers in early graves and gardens

There are graves carbon-dated to be 11,000 years old, that were lined with sage and snapdragon flowers. Artists and craftsmen have painted flowers for thousands of years.

In the royal cemetery at Ur (Iraq), Queen Pu-Abi's tomb contained an elaborate headdress with gold lotus petals and leaves of lapis lazuli. The queen was buried in 2500 BC.

There are records of flowers having been present in early graves and tombs, left to honor the dead and the gods. In Pharaoh Tutankhamun's tomb (dated at 1323 BC) there were floral garlands of cornflowers, lotus and willow.

The spring frescos on Akrotiri, a village on the Greek island of Santorini, survived the volcanic eruption in 1500 BC. They feature birds and blossoming lilies. Remnants of frescos of garden scenes on courtyard walls and mosaic tiles have survived the eruption of Mount Vesuvius of 79AD in Pompeii and Herculaneum. There are paintings of waterlilies, ivy and oleanders, and a fresco showing the various stages of perfume production using rose, fennel and myrrh as ingredients.

The language of flowers

In the 19th century in France and England, a culture developed that gave symbolic meaning to specific flowers. The tradition probably came from Turkey, where a small purse containing a flower and other miscellaneous plant leaves would be given as a love token by a suitor to his beloved.

In 1819 in Paris, a book called ".The Language of Flowers" was published. Flowers were listed by season, and specific flowers carried specific messages. A marigold meant despair, a sunflower constancy, a rose bud with its thorns intact could mean "I fear, but I am in hope". The book

was very popular and reprinted several times. There was a slightly risqué aspect to it, as these flowers could be used to facilitate all kinds of romantic encounters.

Nosegays and tussie-mussies (an antique floral corsage), were very popular in Victorian England. Some flowers still contain the same messages to this day.

Here are a few charming symbolic meanings:

- A carnation represents capriciousness and fascination.

- A tulip represents perfect love and fame.

- A zinnia represents thoughts of absent friends and constancy.

- A lilac represents beauty and youthful innocence.

- An iris represents faith, wisdom and valor.

Travel

I am grateful, largely through my husband's work, that I could be a travelling companion and visit fascinating places. The world has afforded me some unexpected pleasures. My camera is my sketch book capturing unusual images for future paintings. A photograph can present light and shadow in intricate detail. Some fond memories include an old flower-seller in Suzhou, China, selling tiny fragrant bunches of jasmine, a grey stone monastery in Provence with a field of lavender, plumeria bushes with many blossoms growing wild in Bali. Everywhere you look on the island of Bali, on street corners, hotel lobbies, house entrances, Hindu temples, parks and even supermarkets you can find small square palm leaf trays filled with frangipani, ylang-ylang and impatiens with incense on top. These charming mini-arrangements are offerings to their nature spirits, gods and demons.

On a visit to Tokyo in the spring we saw groups of photographers taking pictures of various cherry trees in blossom. I am certain that some of the pictures ended up in travel brochures.

I will never forget a glorious shrub loaded down with many passion flowers in Cinque Terre, in Italy, but perhaps the most unusual was the thirty-six inch diameter rafflesia in the rainforest in Borneo. It smells like dead carrion. It is the largest flower in the world and only blooms once. It also has another name, - "the stinking corpse lily"!

Flowers as food drink and medicine

Edible flowers not only delight the eye with their color, but can add distinctive flavor to lots of dishes. Some make lovely herbal teas. Others make strong medicine and have been used medicinally throughout recorded history. Here are a few common ones.

- The sunflower has large seeds easily hulled for snacking and are also pressed into oil.

- Nasturtiums have edible leaves and flowers that add a peppery, sweet spicy taste to a salad.

- The calendula produces oils that become active ingredients in creams for burns or injured skin. The petals are edible and can be chopped and added to eggs or rice. Its flavor is spicy and tangy and the flower is also known as "poor man's saffron".

- Lavender has a rosemary-mint taste and adds an interesting flavor to honey and chocolate. It has disinfectant properties and can be used as an essential oil in aromatherapy for its calming effect.

- The purple coneflower (also known as echinacea) has immunity boosting properties. Its roots, seeds and flowers all have medicinal uses. It is a popular home remedy for colds.

- The dandelion has greens that taste like arugula. It contains vitamin B and C as well as potassium and manganese. Dandelion tea serves as a diuretic and it also soothes digestive problems.

- The passion flower has a delicious fruit that makes a lovely tea. It reduces anxiety, lowers blood pressure and promotes relaxation.

For the birds and bees.

Let me put on my amateur botanist's hat for a moment and introduce you to the beautiful Stargazer Lily (see page 60). If one takes a close look at it, it is certainly a drama queen, with big bold curves, a heady fragrance, lots of green tubey bits, and cheeky red spots. Its petals are like an outdoor café for a hungry bee to visit, have a little snack and a short rest. Then it will help itself to a nutritious drink of nectar.

A couple of botanical terms may be helpful: the long green rod in the middle is called the pistil, and its purplish colored tip (stigma) is very sticky. Its purpose is to catch the pollen that comes to it thanks to the help of the visiting bee. The pollen is contained in the anther that sits on top of the stamen (of which there are six). The anther looks like a miniature hot dog. The pollen dust clings to the visitor and the bee will take it back to the hive to feed to the inhabitants. Some of the pollen will stick to the stigma and then travel down the pistil to the ovary. The ovary contains the eggs ready for fertilization.

Open to interpretation

Two friends and I were looking at my Roses of Sharon hibiscus painting. One friend said it reminded her of a balmy spring evening in Paris, with a couple of ladies in floating chiffon dresses enjoying the night views of the "City of Light". (Paris was one of the first cities to adopt gas lighting. It became known as the city of light as well as the city of love).

My other friend said it recalled a lunch we had had in the Beaches, in Toronto, in early summer. We were walking past a greengrocer's store, deep in discussion about the existence of God. There were rows upon rows of gorgeous pale blue petunias just waiting to be taken home and planted in someone's garden. We just stood still looking at the life and presence of this beauty. How could there not be a God? And then there was the perfume (added perhaps as an "amen").

When I painted the picture of the hibiscus I wanted two large blooms crowding each other a little, with a spent bloom in the corner and a bud in the other. I named it "Yesterday, Today and Tomorrow". Of course, "Today" was given pride of place.

It makes me happy to think that each of us in viewing a flower painting brings one's own life experience to the moment and interprets it in an individual way that brings one pleasure.

My studio

My painting space is in my home in Toronto. The upstairs room where I paint has windows on three sides, affording excellent natural light to work during the day. Canvasses are piled high, some on walls, some littering the floor. There is a profusion of color, - enough to brighten the dullest day, and to warm the heart, especially in winter with below zero outside temperatures and ice underfoot. No matter how unpleasant the weather may be, happiness is being in my studio working on a painting. A hardy rubber plant and a split leaf philodendron inspire the greens that I often favor for a background to my flowers.

I recall a teacher saying that "a painting is not finished, it is abandoned". Sometimes a work in progress sits with its face to the wall for weeks, until I am ready to give it another look, and be open to what it tells me it needs to make it better. This is my space: I enter it with joy and expectation. My canvas, acrylic paints, brushes, easel surround me. Everything is here because I want it here.

Painting process

To me, painting is a mystery, one sits staring at a blank canvas, wondering where the journey will lead. There is the magic of creating three dimensions out of two, wanting the illusion to captivate the viewer. There is discipline. I paint almost every day, usually in the morning. I started to paint during a very difficult time in my personal life. I found that my problems and stress moved to the back of the bus while I was absorbed in my art, and I entered a different holistic space. I loved that space. I have always had the greatest respect for the healing aspects of creativity. I don't know if I am inside or outside of time. It seems to have fallen away. Painting becomes meditation. The profound teachings of spiritual teachers are present between the brush strokes.

I paint my flowers big - the "bird's eye view", much larger than life. My style is fairly realistic, sometimes a little more impressionistic, with some mixed media. I am particularly fond of using sand, heavy gesso and various Japanese papers.

I sometimes start with a paper sketch the same size as the flower will be on the canvas, to work out technical botanical details and composition. Otherwise I draw right on the canvas with water-soluble crayons that are easily removed. There is the challenge of giving the impression of floral textures, - crinkled, velvety, prickly, smooth, hairy, feathery, matte, glossy; - the list could go on and on. There is certainly frustration in the challenges of getting the paint on the canvas, - faulty technique, wrong color combinations, light and shadow problems, composition, - sometimes discovered much too late in the process so the painting is doomed to the garbage bin.

A lovely thing about painting, - it is accessible. It is never too late to start. There are no entry exams. Just a willingness to open up and awaken your senses, and to observe (and practice).

And then there is the joy. "The earth laughs in flowers" – Ralph Waldo Emerson.

Anne Linden
January 2018

WITH BRUSH IN HAND I CONTEMPLATE THE BEAUTY,

THE INCREDIBLE VARIETY OF FORM AND SHAPE AND

COLOUR - THE WONDER OF THE NATURAL WORLD.

MY HEART QUICKENS AND WITH A FEELING

OF GREAT AWE AND GRATITUDE, I BEGIN

TO PAINT ANOTHER FLOWER...

ANNE LINDEN

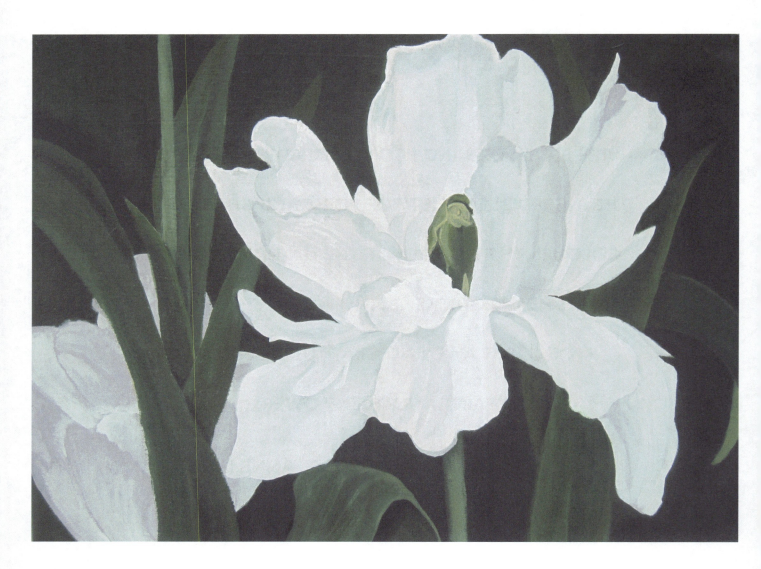

Welcoming a New Day

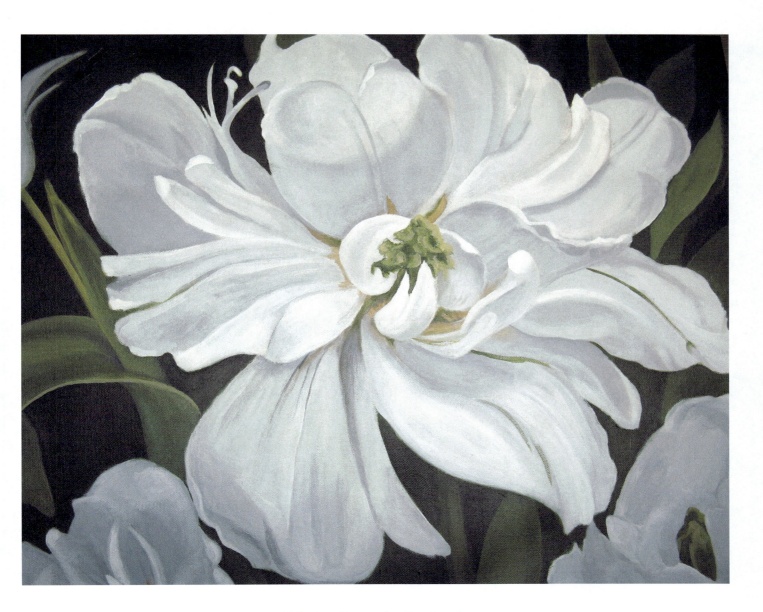

White Double Tulip #2

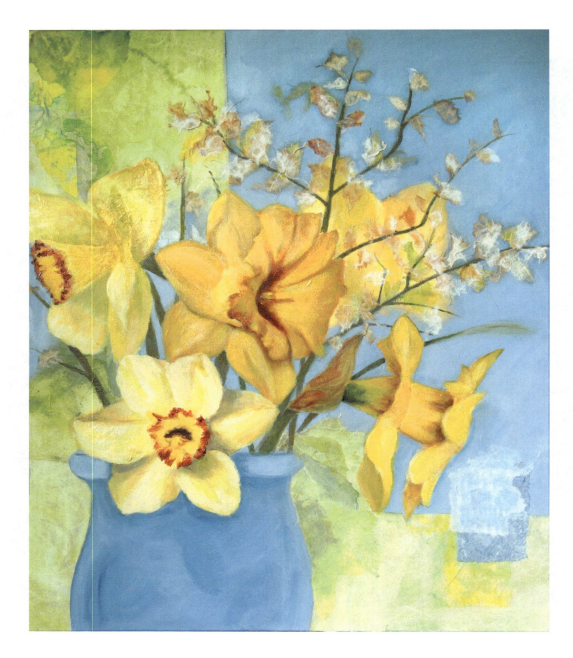

Golden Daffodils

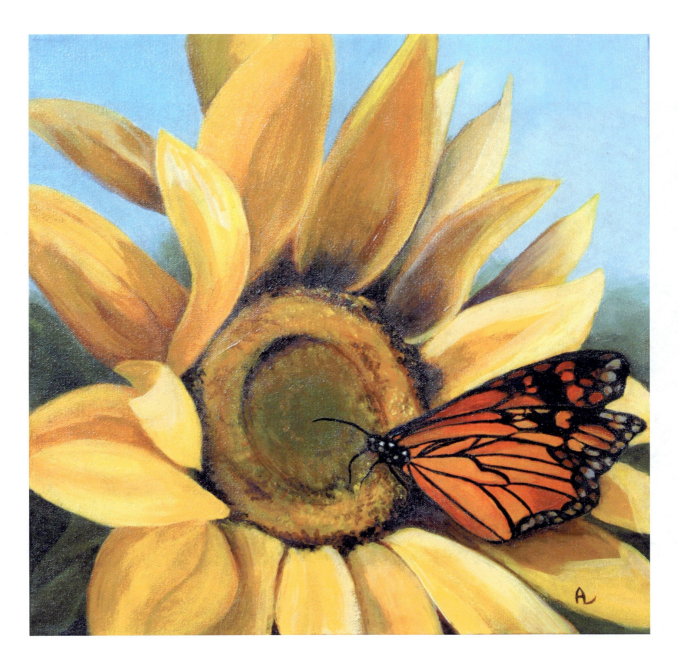

On a Summer's Day

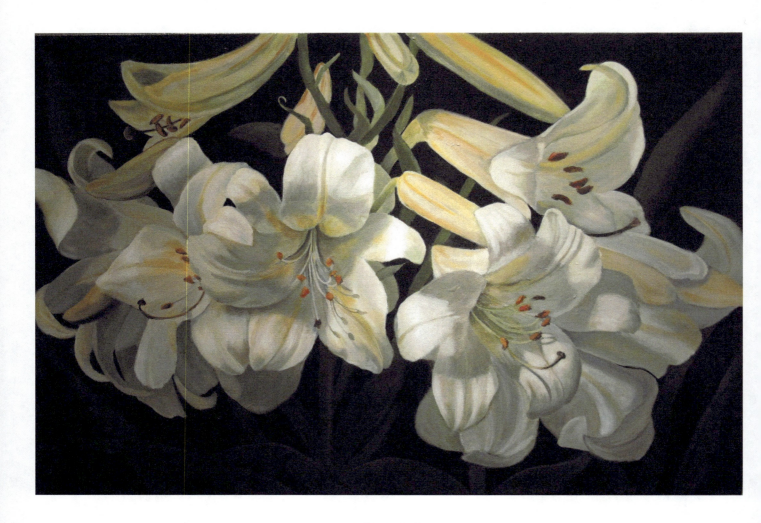

Allelujah

And which of you by being anxious can add
one cubit to his life span? Consider the
lilies of the field, how they grow; they neither
toil nor spin; yet even Solomon in all his
glory was not arrayed like one of these.

<div align="right">Matthew 6:27-29</div>

Let the beauty you love be what you do.
There are a hundred ways to kneel and kiss the
ground.

<div align="right">Rumi</div>

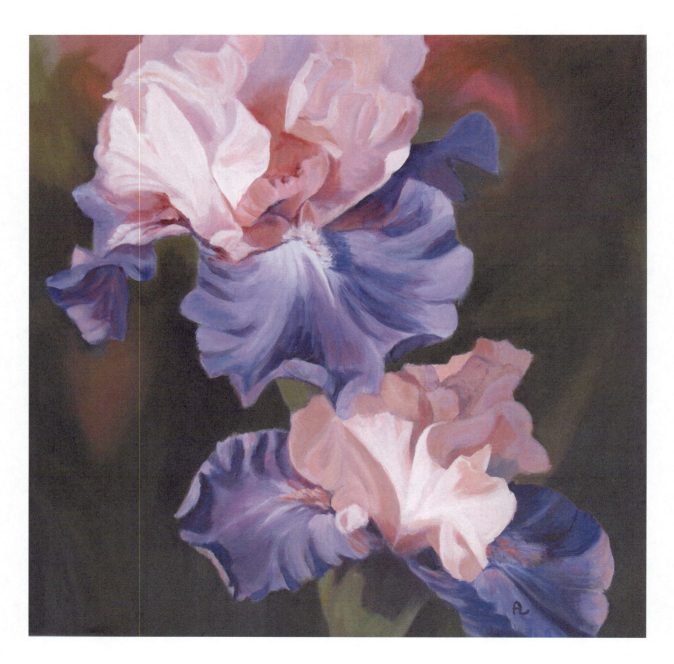

Serenity

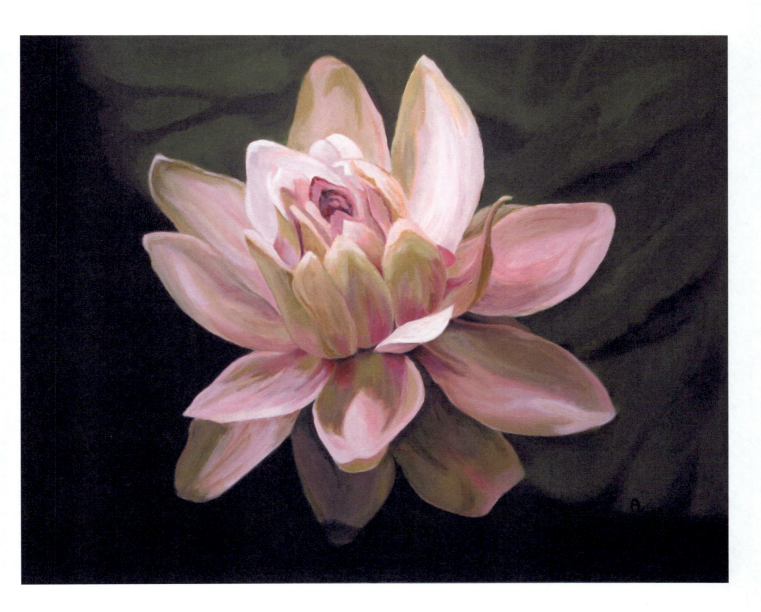

Amazonian Water Lily

May I be at Peace. May my heart remain open. May I know the light of my own true nature. May I be healed. May I be a source of healing in all creatures.

Thich Nhat Hanh

We are not human beings having a spiritual experience. We are spiritual beings having a human experience.

Teilhard de Chardin

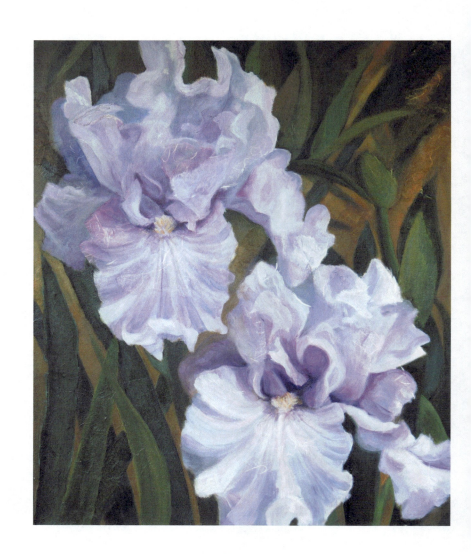

Les Belles Soeurs

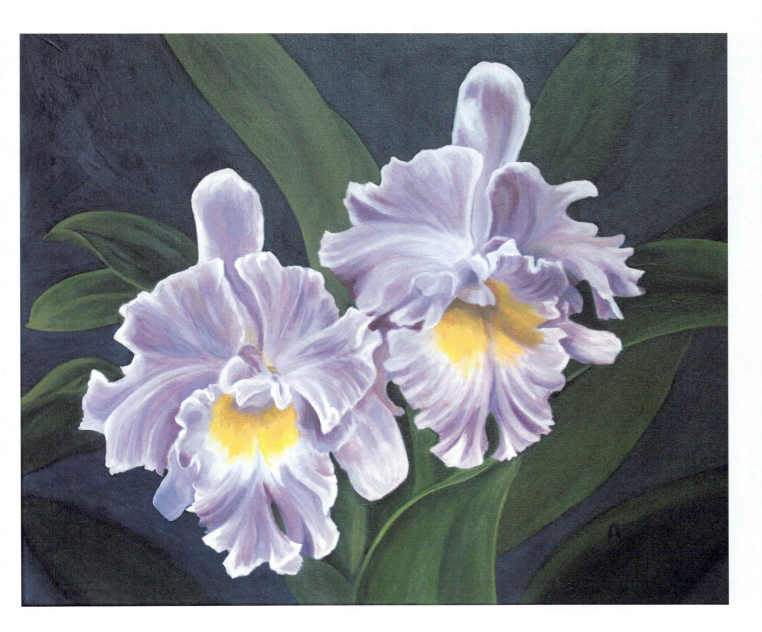

Cattleya Orchids

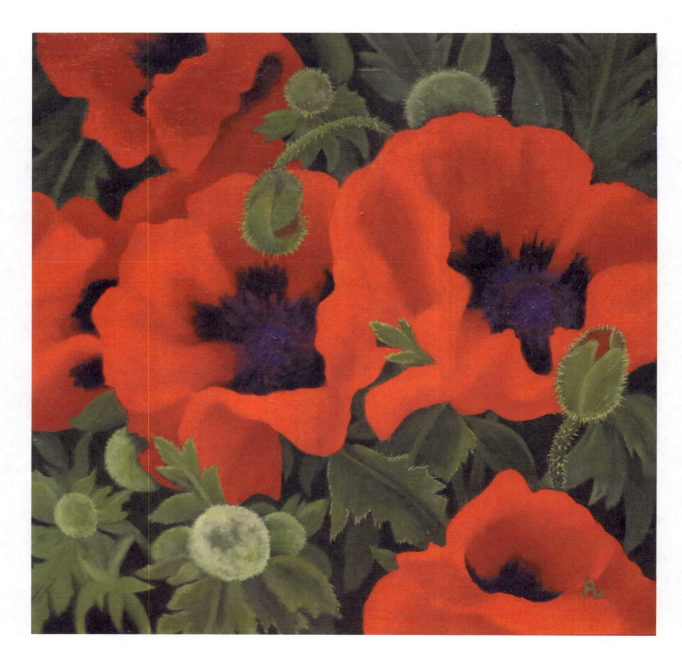

A Tangle of Poppies

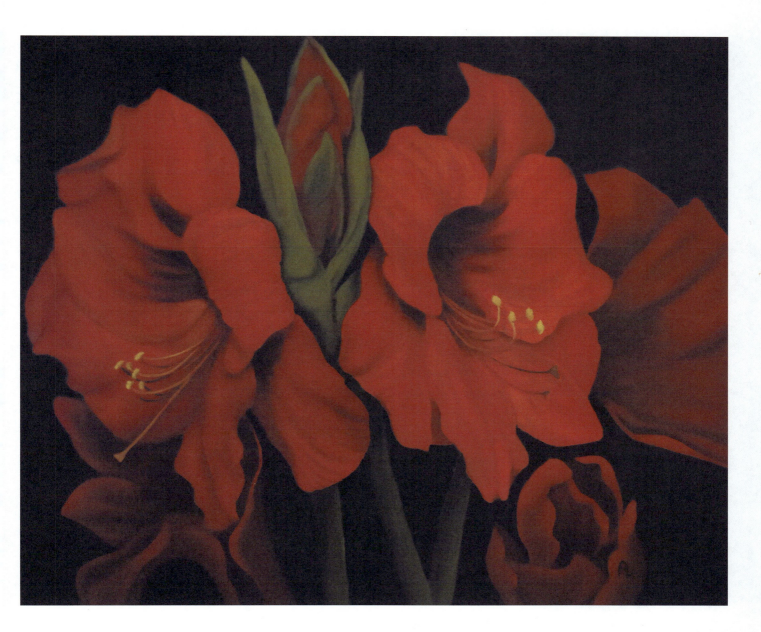

Red Amaryllis

Look to this day for it is life, the very life of life. In its brief course lie all the verities and realities of our existence, - the bliss of growth, the glory of action, and the splendour of beauty. For yesterday is but a dream, and tomorrow is only a vision, but today, - well lived, makes every yesterday a dream of happiness and every tomorrow a vision of hope. Look well therefore unto this day.

Ancient Sanskrit poem

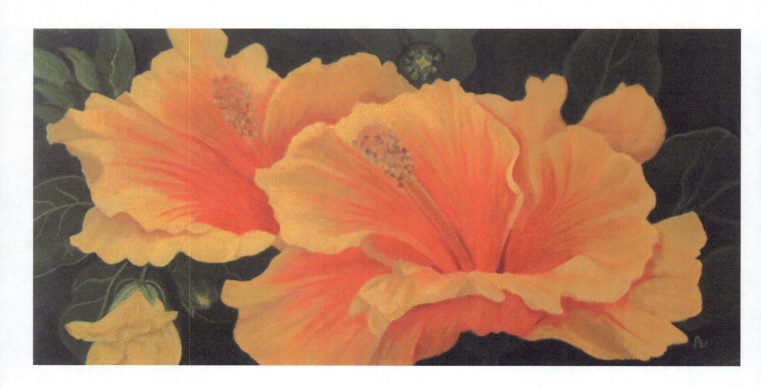

One Shining Golden Moment

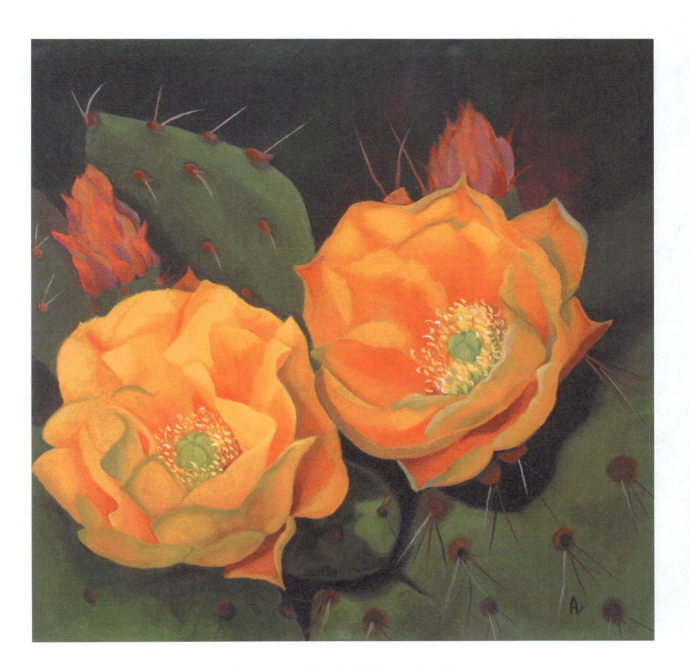

Sonoran Desert Beauty #3

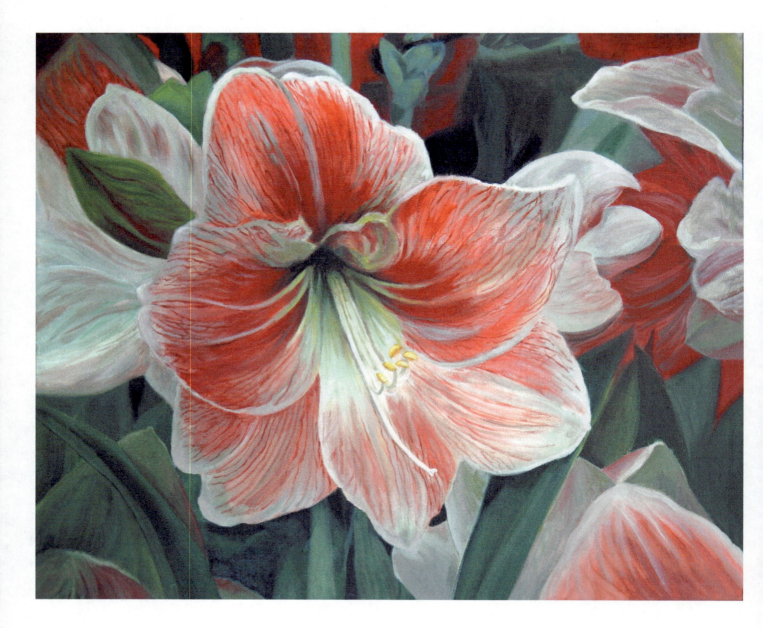

Amaryllis

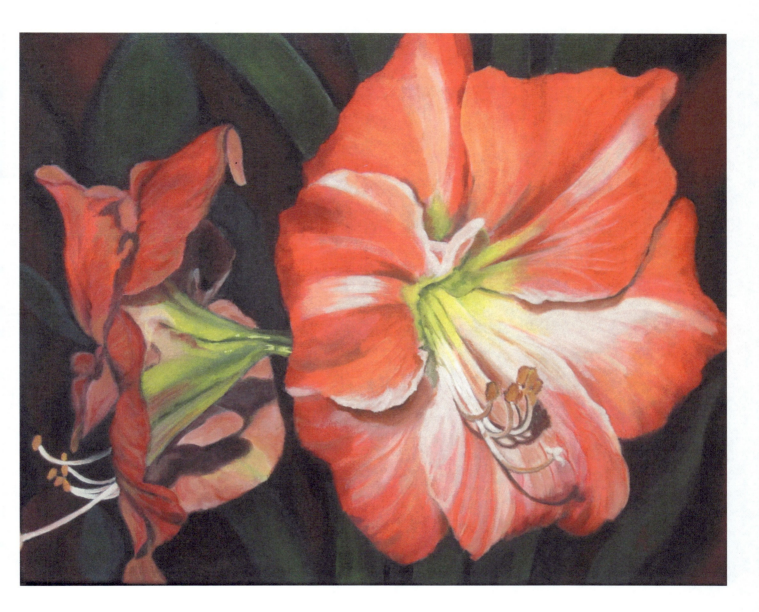

Amaryllis on Dark Ground

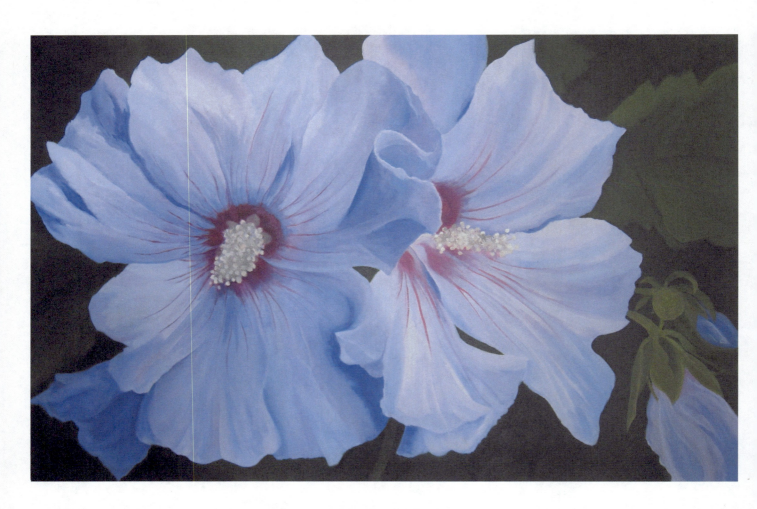

Yesterday, Today and Tomorrow

A flower is relatively small.

Everyone has many associations with a flower, - the idea of flowers. Still in a way, nobody sees a flower – really – it is so small – we haven't time, and to see takes time, like to have a friend takes time.

So I said to myself – I'll paint what I see – what the flower is to me, but I will paint it big, and they will be surprised into taking time to look at it.

<div align="right">Georgia O'Keeffe</div>

The purpose of art is to wash the dust of daily life off our souls.

<div align="right">Pablo Picasso</div>

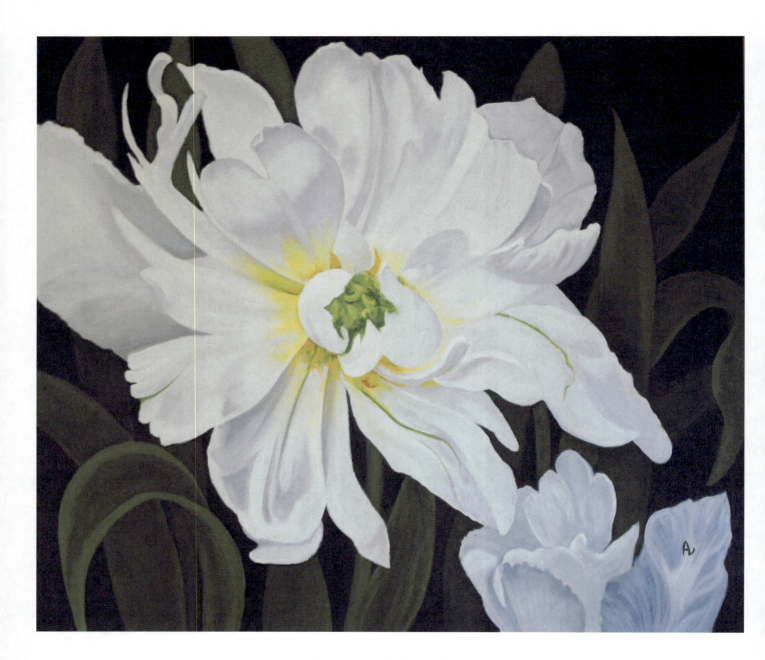

White Double Tulip #3

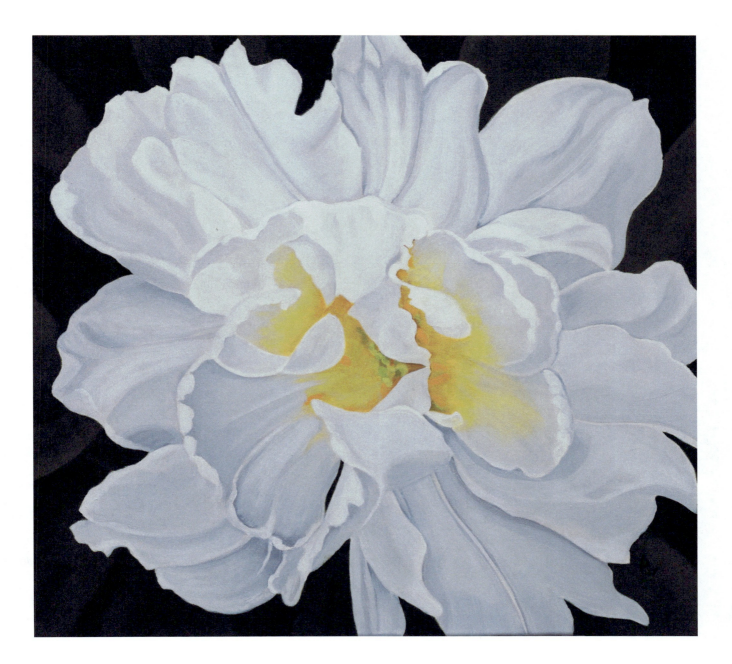

White Double Tulip #4

Be silly. Be honest. Be kind.

Ralph Waldo Emerson

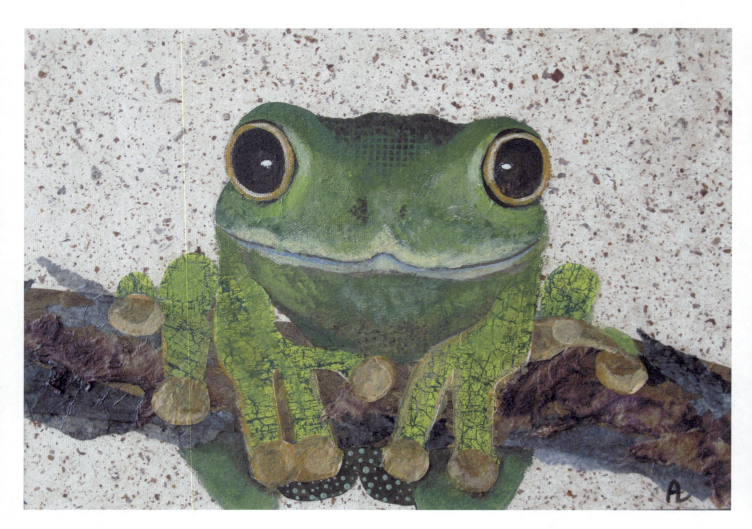

Frog #1

Creativity is about making mistakes. Art is knowing what mistakes to keep.

Anonymous

Use the talent you possess, for the woods would be silent if no bird sang except the best.

Barnstable Patriot

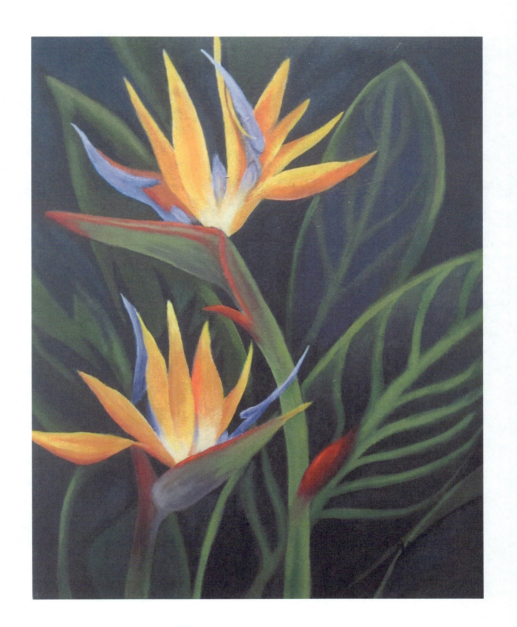

Birds of Paradise

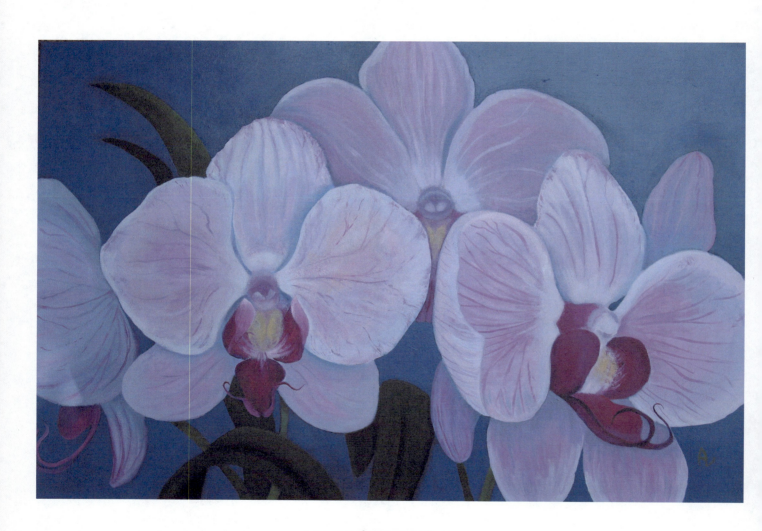

Unspoken Dialogue

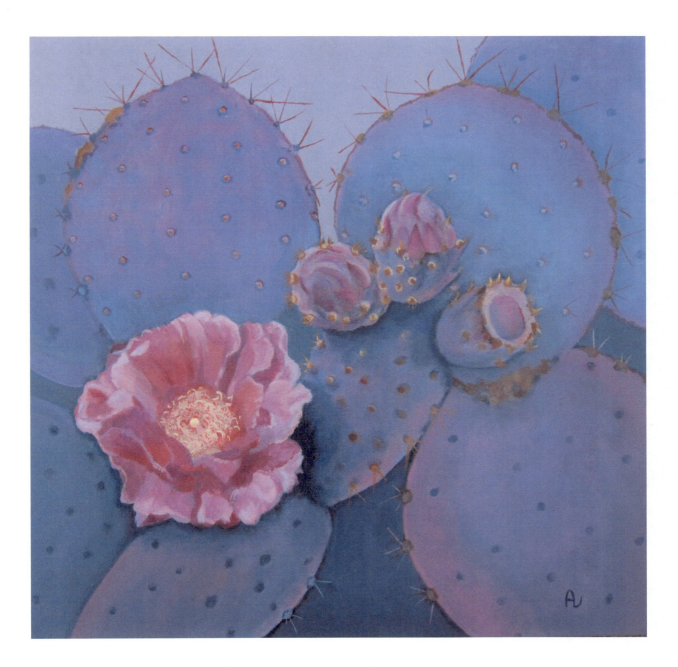

Sonoran Desert Beauty #1

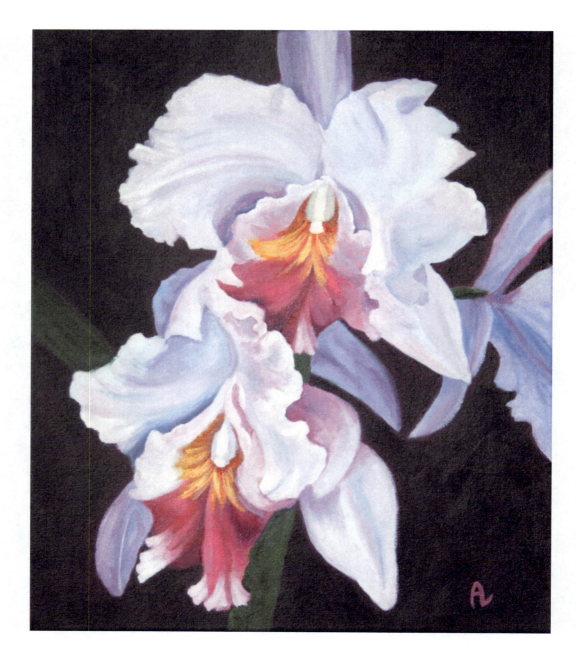

Cattleya Orchids On a Dark Ground

Let us be grateful to the people who make us happy; they are the charming gardeners that make our souls blossom.

Marcel Proust

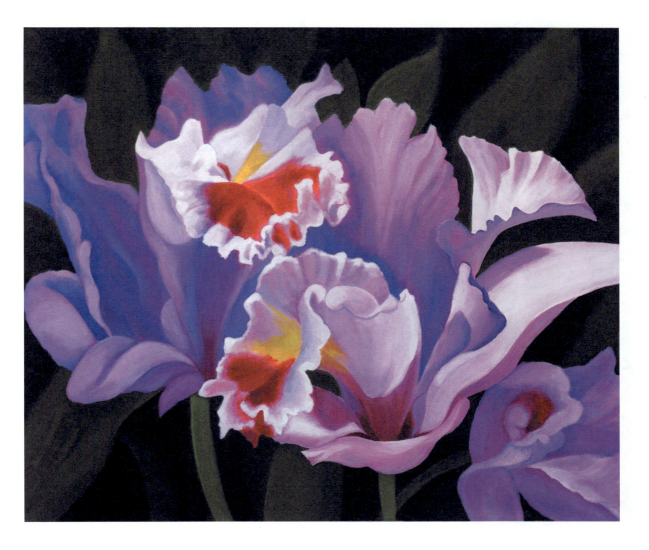

A Dream Within a Dream

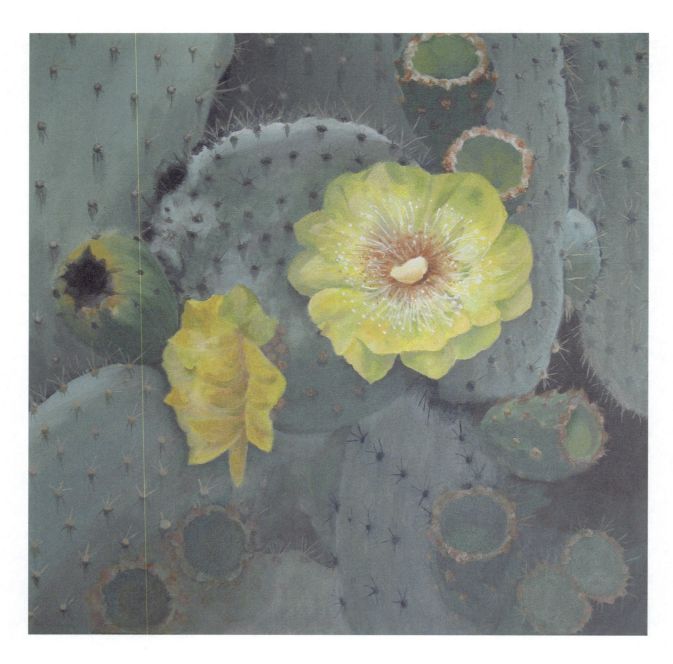

Sonoran Desert Beauty #2

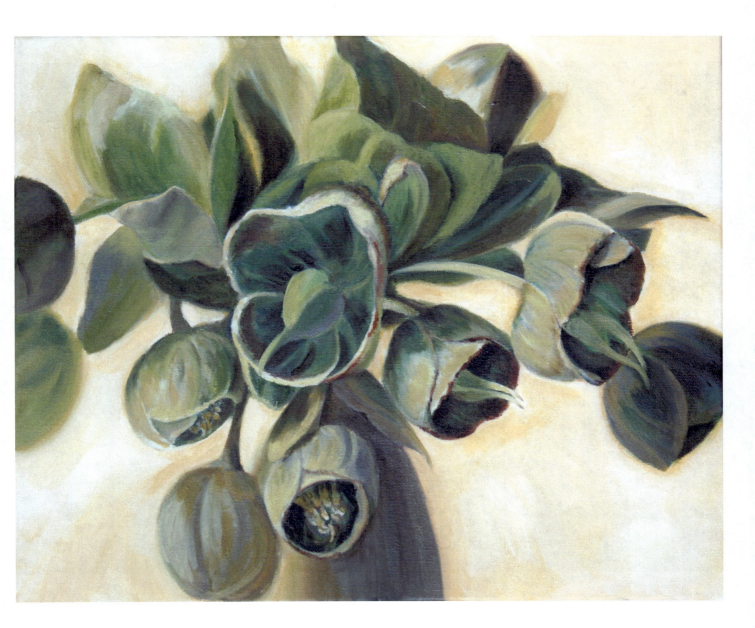

Spirit Dance

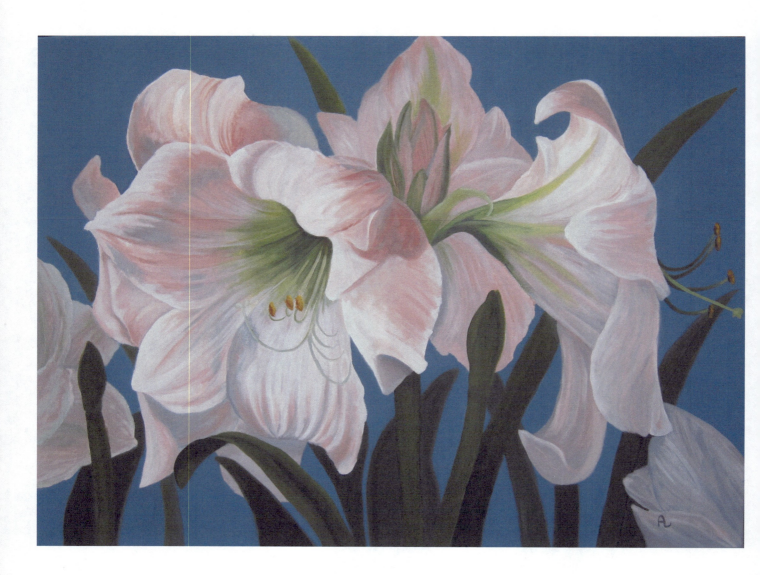

Song at Evening

Security is mostly a superstition. It does not exist in nature, nor do the children of men as a whole experience it. Avoiding danger is no safer in the long run than outright exposure. Life is either a daring adventure or nothing. To keep our face towards change and behave like free spirits in the presence of fate is strength undefeatable.

Helen Keller

One of the deep secrets of life is that all that is really worth doing is what we do for others.

Lewis Carroll

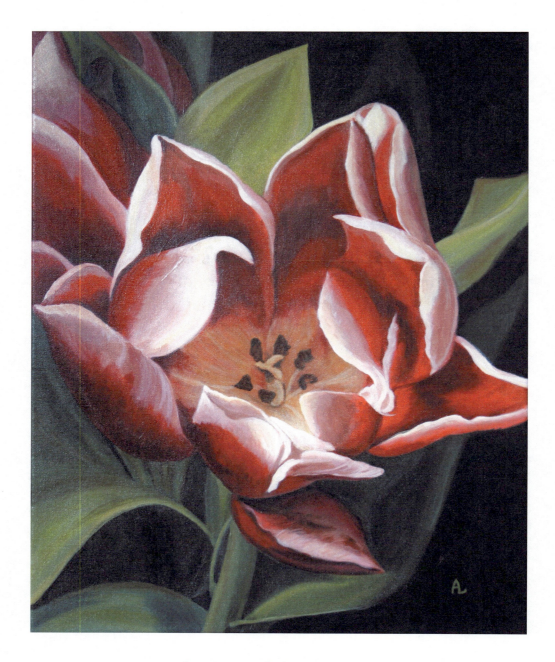

The Last of the Bouquet

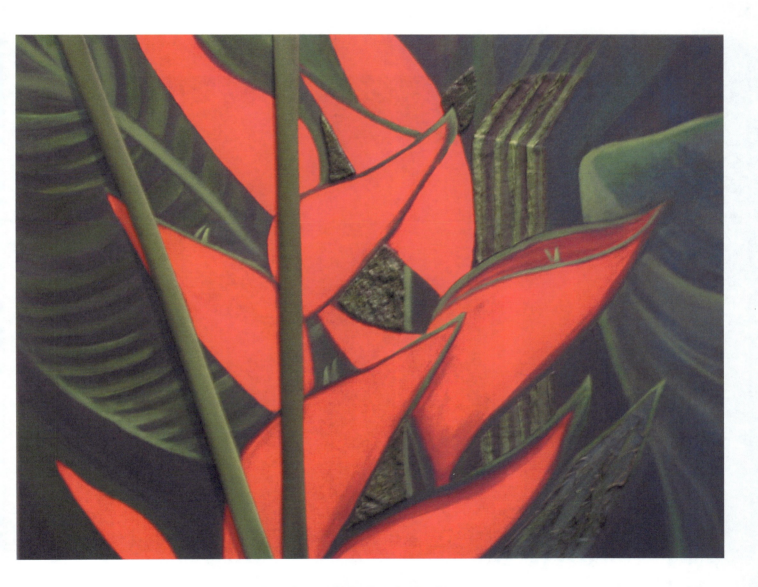

Garden of Earthly Delights

Follow your bliss.

Joseph Campbell

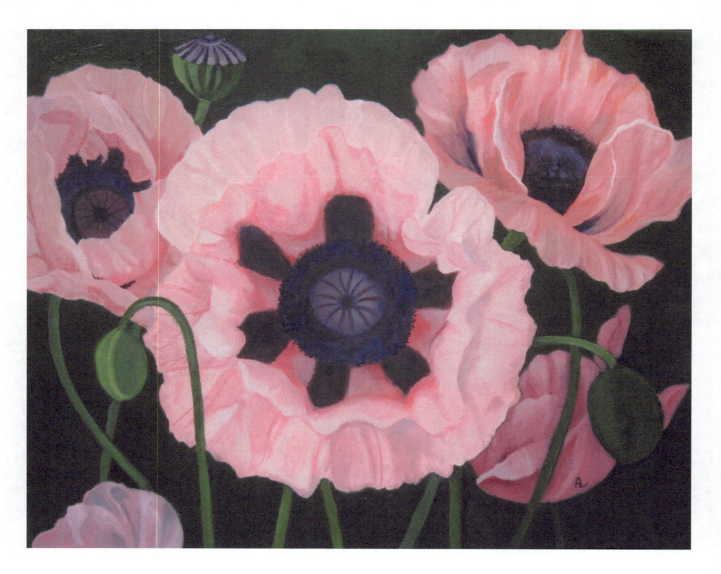

Pink Poppies

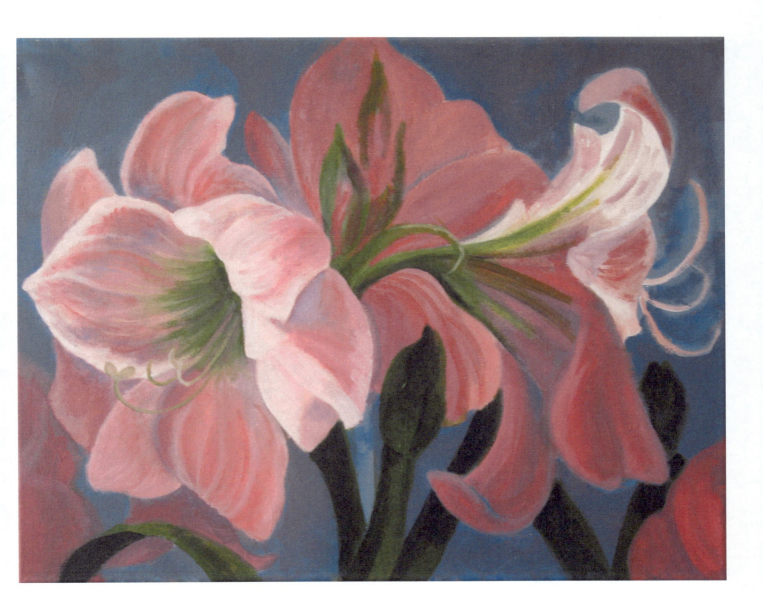

Simple Joy

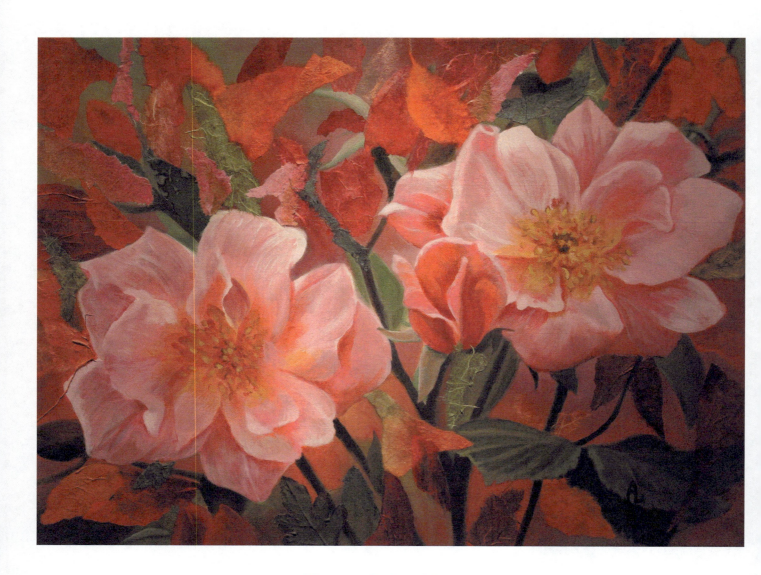

By any Other Name

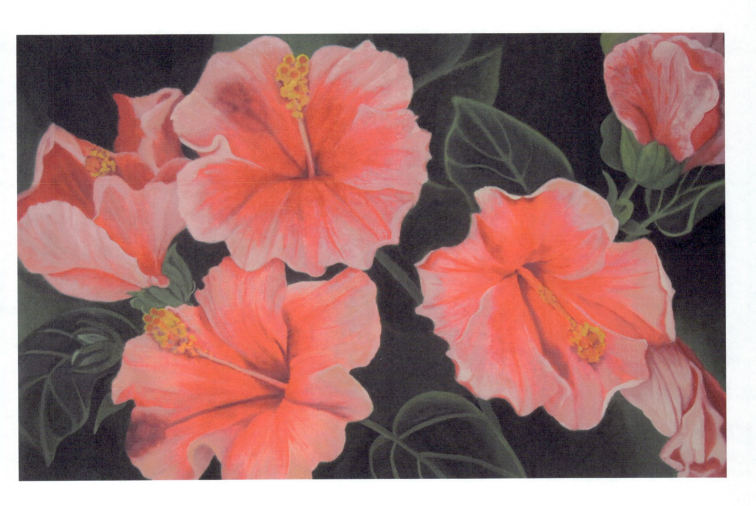

From Kelsie's Garden

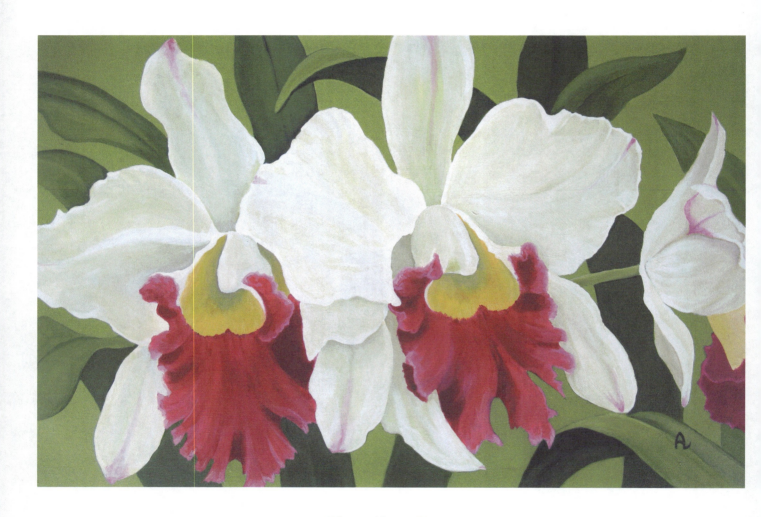

Three in a Row

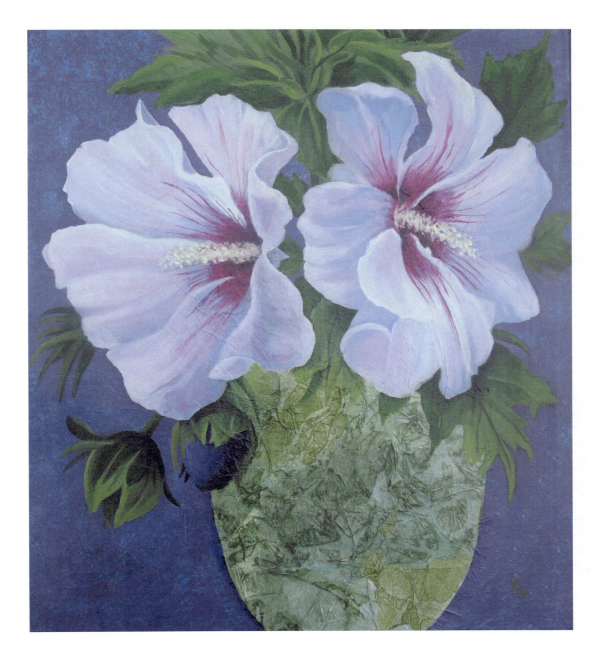

Best Friends

Carpe diem quam minimum
credula postero.

 Horace

If the only prayer you said
was "thank you", that
would suffice.

 Meister Eckhart

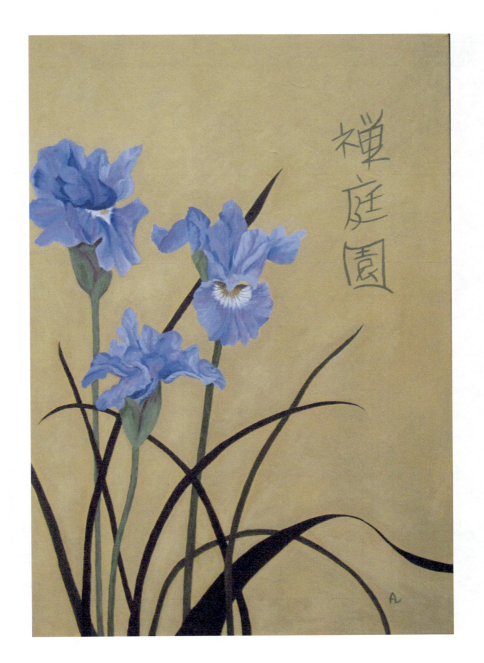

Garden of Serenity

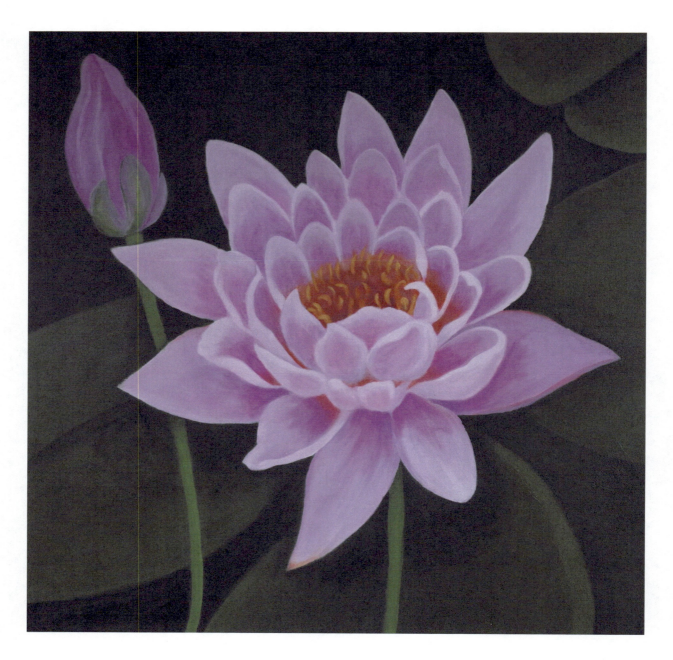

Between two Worlds

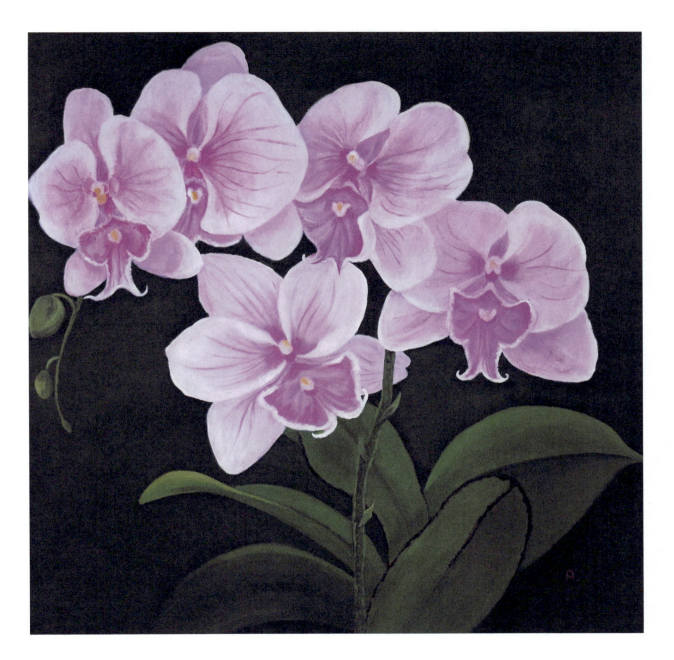

All Together in a Row

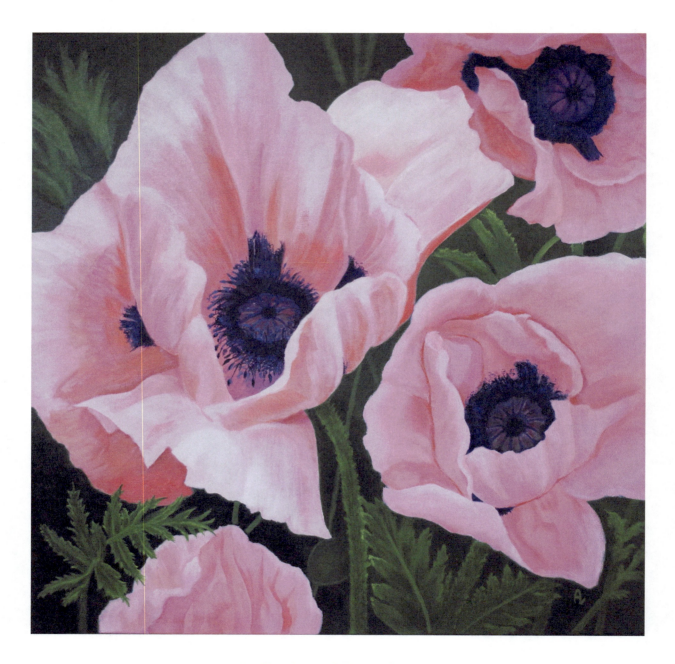

In Praise of Poppies #2

For nothing worthy proving can be proven nor yet disproven: wherefore thou be wise, cleave ever to the sunnier side of doubt.

Alfred, Lord Tennyson

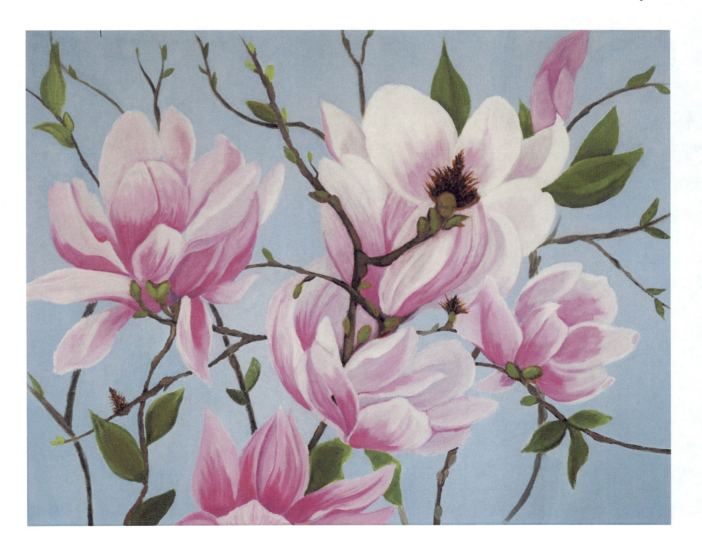

Spring Awakening

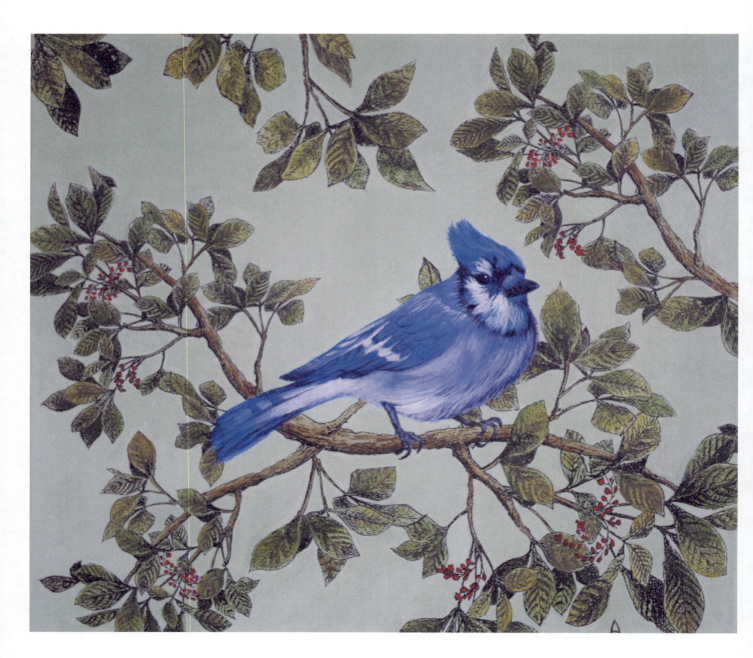

A Bluejay in my Garden

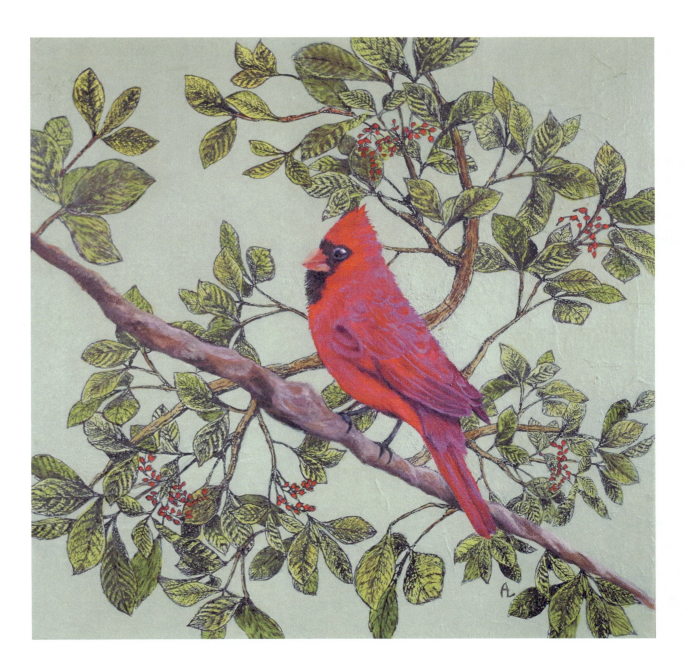

A Cardinal in my Garden

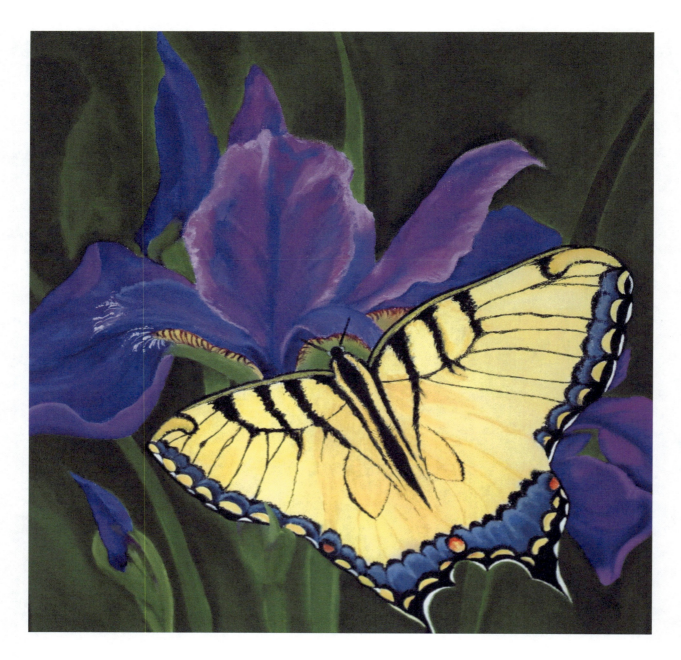

Small is Beautiful

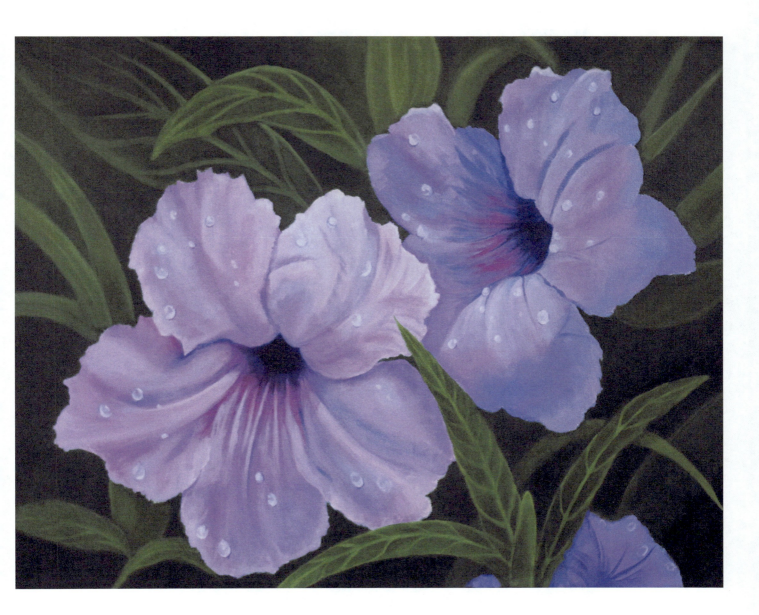

Bali after the Rainfall

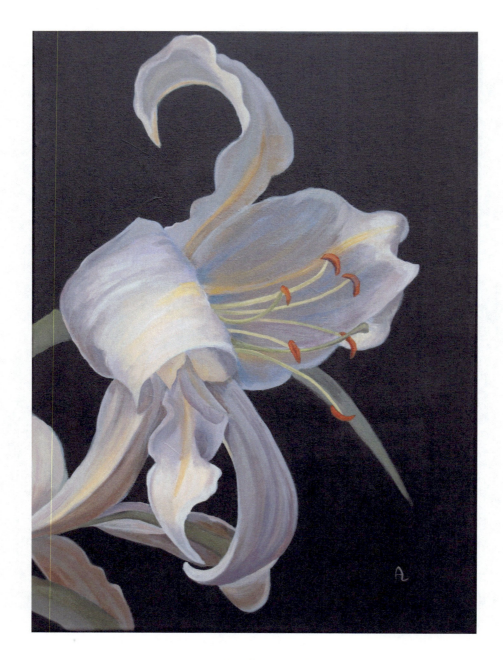

And All is Well

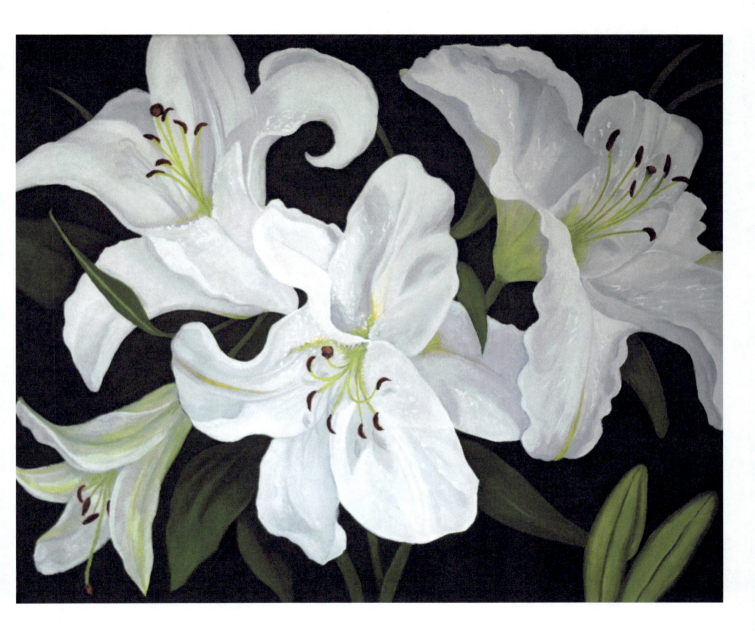

Casa Blanca Beauty

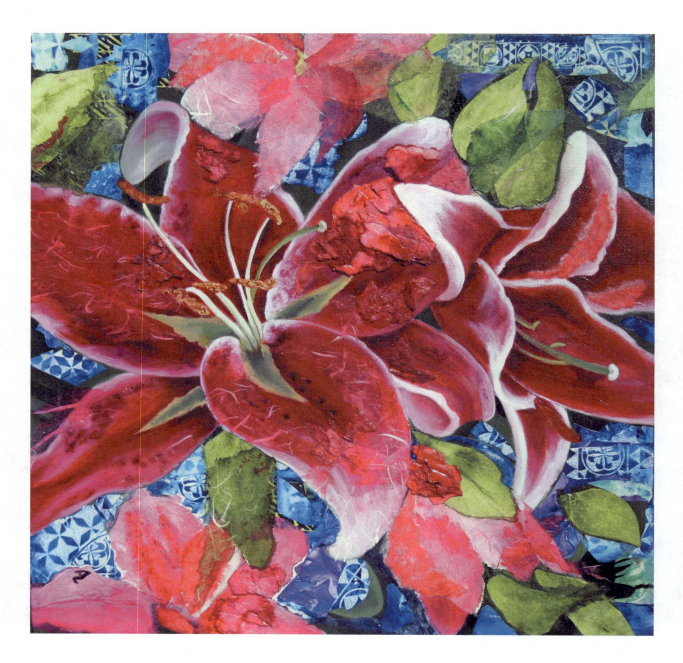

Stargazer with Collage

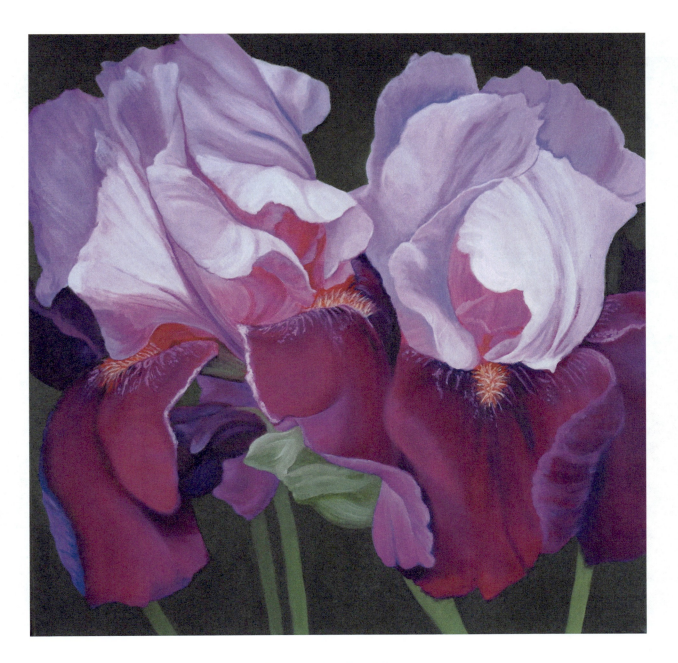

Towards the Light

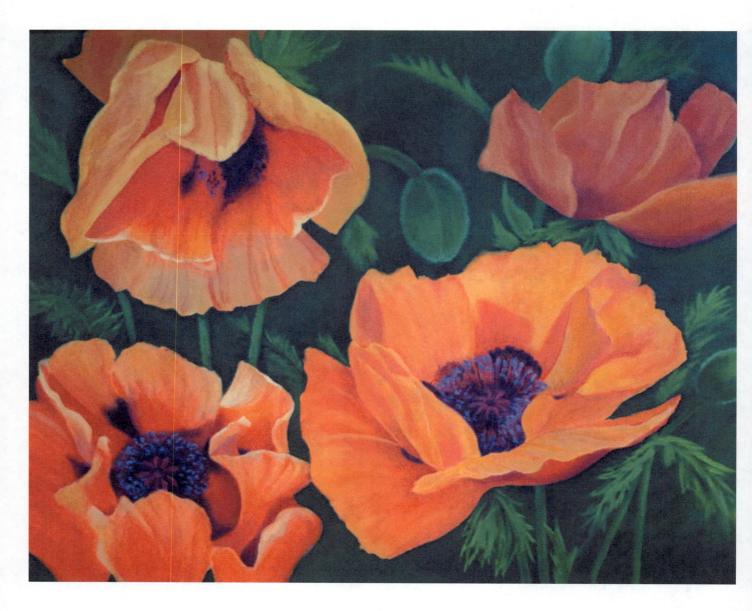

In Praise of Poppies #1

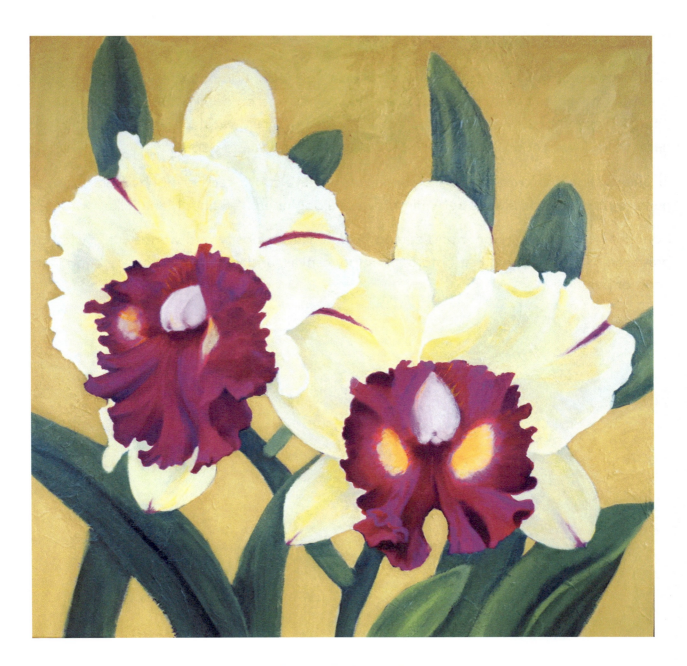

Orchids on Golden Ground

The journey continues

All the new smart technology left me in the dust ages ago. I do not want to play that game; - that is for my children and grandkids. Instead I want to go on doing what I do, recording and interpreting the beauty of the natural world. Art gives my life satisfaction and meaning. Right here, right now, I choose to live a life of more spaciousness and depth.

"If an angel deigns to come, it will be because you have convinced her, not by tears but by your humble resolve to be always beginning; always a beginner". – Rainer Maria Rilke

I delight in being a beginner and seeing flowers with curiosity and wonder. It is with much gratitude that once again I sit before an empty canvas, and with joy and expectation I begin another painting.

Printed in the United States
By Bookmasters